D0789221

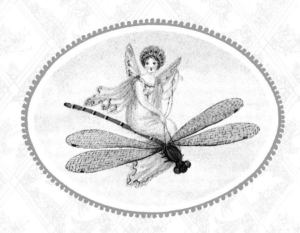

A REGENCY LADY'S

FAERY BOWER

Amelia Jane Murray

A REGENCY LADY'S

FAERY BOWER

Amelia Jane Murray

HOLT, RINEHART AND WINSTON NEW YORK

William Collins Sons & Co Ltd
London · Glasgow · Sydney · Auckland
Toronto · Johannesburg

Copyright © 1985 by April Agnew-Somerville
All rights reserved, including the right to reproduce
this book or portions thereof in any form.

First published in the United States in 1985 by
Holt, Rinehart and Winston, 383 Madison Avenue,
New York, New York 10017.

LC Number: 85-045321
ISBN: 0-03-006109-1
First American Edition

Designer: Enid Fairhead
Jacket and decorations by Rosemary Lowndes and Claude Kailer
Printed in Great Britain
1 3 5 7 9 10 8 6 4 2

Acknowledgement is made to Miss Harrison
of the Manx Museum for her helpful assistance.

ISBN 0-03-006109-1

A Private View of Fairyland:

AMELIA JANE MURRAY

1800–1896

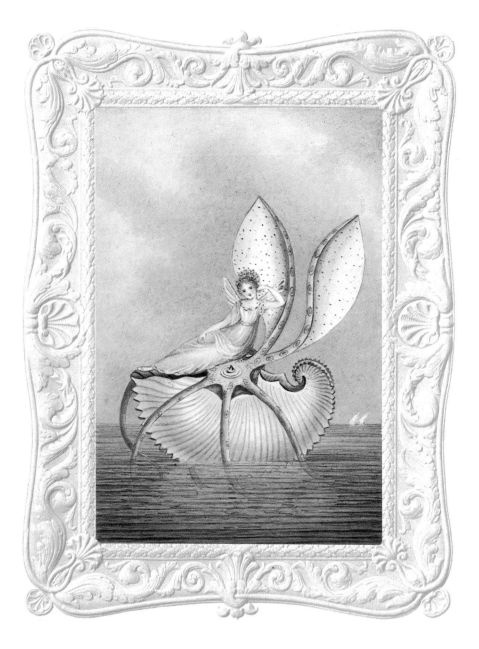

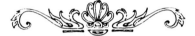

I N SHAKESPEARE's play *The Tempest* Prospero invokes the
aid of both the nymph Ariel and

> Ye elves of hills, brooks, standing lakes and groves
> And ye that on the sands with printless foot
> Do chase the ebbing Neptune . . .

to rule the magical island of which he was Governor.
Shakespeare's *The Tempest* and *The Midsummer Night's
Dream* became in the early nineteenth century one of the
main sources of inspiration for several artists who reacted
against the materialism of the age by painting the world of
fairyland. For Amelia Jane Murray, who in the 1820's
painted the remarkable fairies which make their first
public appearance in this book, Prospero's words, and the
theme of *The Tempest* possessed both inspiration and a
particular appositeness.

Like Shakespeare's Miranda, Amelia Jane lived on an
island with magical associations, for she was born in 1800
at Port-e-Chee on the Isle of Man, where legend has it, the
magician who lived on the island up to the fifth century
used to make a mist to hide the coast line from its invaders.
It is claimed that from its highest point, Snaefell, on a clear
day one may see six Kingdoms: England, Scotland, Wales,
Ireland, Man and the Kingdom of heaven.

Both Amelia Jane's lineage, as well as her birthplace were romantically appropriate for an artist who was to produce remarkable paintings of fairies. Her family had for generations played a major role in the history of the Isle of Man, holding the sovereign rights to the Island by paying the fee of two falcons to the English crown at every coronation of an English Monarch. The complex and intertwined story of both her ancestry and the Island must be told in some detail to fully understand the background to her life and work.

The Isle of Man is both Celtic and Norse. Until 1266 it belonged to Norway, its Viking rulers slowly adopting the Christian faith of the conquered Celts. Then the Scots took it over, until Edward III made England its overlord. In 1406 Henry IV gave it to the Stanley family, who became not only Earls of Derby but Kings of Mann. When that line of Stanleys died out in 1736, the Sovereignty passed to a descendant, the Duke of Atholl, whose family name was Murray. But in 1765 the British Parliament, perturbed by the widespread smuggling on the Island, passed an act buying the Lordship of Mann on behalf of George III. Yet though reduced in power the Murrays remained the principal family on the island, and in 1794 Amelia Jane's Uncle, the fourth Duke of Atholl, was appointed Governor. As a result a great deal of patronage was at his disposal, and he appointed several members of his family to key positions leading to the Manx saying that there were 'Murrays, Murrays every-where'. In 1828 he sold out his remaining rights to the Crown for nearly half a million pounds, resigned, and left the Island.

Castle Mona, Isle of Man

Amelia Jane's father, Lord Henry Murray, was Lt-Colonel of the Royal Manx Fencibles and she was one of six children. Although he died when she was five, her childhood, as the Governor's niece was a privileged one. The family originally lived in the duke's house, Port-E-Chee, but later their home was a house named Mount Murray, five miles south of Douglas. As she grew up the town flourished, becoming a fashionable centre during the summer months for visiting families from the north west of England, with theatres, concerts, lectures, dances at the Assembly Rooms and Balls at Castle Mona, the Governor's newly built and impressive residence, designed by the Shrewsbury architect George Stewart, which is now a hotel. Amelia Jane, or Emily as she preferred to be

called, can be pictured as enjoying a daily routine not dissimilar to that of one of Jane Austen's heroines. Like them she would have frequented the circulating library, and acquired the accomplishments so necessary to polite society of dancing, singing and piano lessons. She also probably attended a young ladies seminary in Douglas, of the type parodied by Lewis Carroll in *Alice in Wonderland*. Certainly the surrealistic lessons described by the Mock Turtle would have been eminently suitable for Emily. They included 'Mystery, Ancient and Modern, Sea-ography, and then Drawling – 'The Drawling Master was an old Conger eel that used to come once a week: *he* taught us Drawling, Stretching and Fainting in coils.'

Unlike the Mock Turtle, 'painting in oils' did not perhaps feature on Emily's curriculum, but there can be little doubt that she did receive some expert tuition in drawing, sketching and the use of the watercolour medium. There is a family tradition that she was taught by the landscape artist John 'Warwick' Smith (1749-1831) who in 1795 was commissioned by her Uncle the Governor to paint a series of watercolour views of the Isle of Man, although this cannot be verified. It is however possible to detect in her small, precise works, enchantingly mounted in their elaborately embossed mounts, certain artistic influences which may have inspired her delicate fairy fantasies.

On one of the watercolours a fairy reclines in the attitude of Canova's celebrated sculptural full length nude portrait of Pauline Borghese on a beautifully delineated feather, while in another a fairy riding on a bee holds

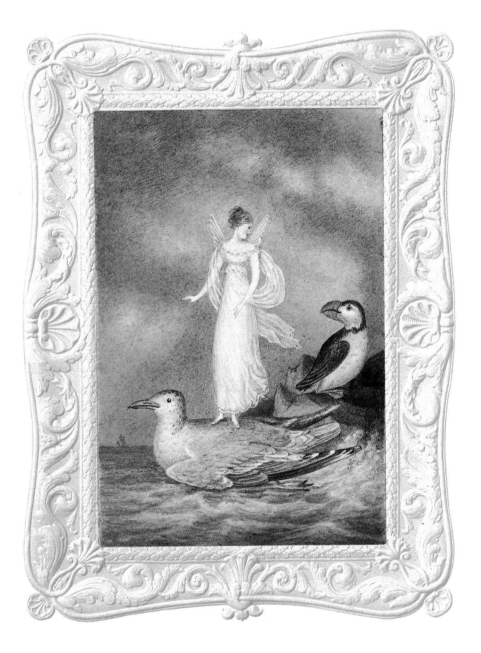

aloft a feather which she uses as a sail. Elsewhere two fairies ride on an owl's back, and a fairy stands lightly on the back of a guillemot, watched by a puffin. All four watercolours show strong evidence of an acquaintance-ship with Thomas Bewick's exquisite woodcuts in the two volumes of his *British Birds*, first published in 1796 and 1797, but frequently reprinted in the next twenty years. Copies of *Bewick's Birds* were, we may surmise, almost certain to have reached an area as rich in birdlife as the Isle of Man. Bewick's volumes contain several delicate vignettes of feathers, and their precise observation would have provided both instruction and inspiration for Emily.

Throughout the *Faery Bower* Emily's fairies are remark-

able for their diaphanous draperies, which reveal an unconscious amalgamation by the artist of contemporary fashions with the classical convention of depicting dancing and flying figures. Such figures occur in both the reliefs of Josiah Wedgwood, and the neo-classic engravings of Thomas Stothard and John Flaxman, all sources with which she was very likely to be familiar. But though such sources elucidate her technique, they do not explain the reason for her obsessive and highly imaginative depiction of fairies. Why, it is pertinent to ask, should a young lady in her twenties be so drawn to this unusual subject?

Sir Walter Scott's *The Minstrelsy of the Scottish Border* published in 1802/3, and the Brothers Grimm's *Kinder und Hausmärchen* published in 1815, began a steady flow of publications of folk stories and legends throughout Europe. One book of particular importance was Thomas Crofton Croker's *Fairy Legends and Traditions of Southern Ireland,* published in various editions between 1825 and 1827. Croker's book was extremely successful, not only because of its text, which introduced its readers to such novel elfin creatures as the Shefro – 'a gregarious fairy who wears a foxglove flower as a cap', but also for its illustrations. They were by William Henry Brooke (1772-1860) and Daniel Maclise (1806-1870), and they possess a delicate, ethereal quality which is closely akin to Emily's watercolours.

But although Emily may have known these illustrations the remarkable originality of her work is plain to see in these pages. Her eye hones in with preternatural clarity on dragon flies, spider's webs, snails crawling on a rosebud,

and the red fuchsia flowers which are such a feature of the Manx hedgerows. Within these acutely observed natural settings her fairies dance, or recline, with the grace and perfect deportment of elegant Regency young ladies. Like young ladies their behaviour is strictly determined by the bounds of propriety – in their case by the restraining borders around the watercolours which must be described in some detail.

In the early nineteenth century young ladies vied with each other in the compilation of Keepsake albums – small books, often beautifully bound, in which were preserved watercolours, poems, engravings and music. These albums were often embellished by the use of 'new and elegant articles in the fancy paper line' to use a description given in a pattern book of 1817 in the Victoria and Albert Museum. 'Fancy pasteboard' and 'emboss'd borders' could be obtained 'in great variety' 'from one eighth inch wide to two inches and a half'. These borders were produced by the use of blind printing or 'gauffrage' a process in which thick paper or card was put through a press under heavy pressure, the uninked dies thus producing a relief pattern of great delicacy. It is pleasant in imagination to follow Emily into her stationer's, and watch her select the particular pasteboard and ornamental border which she required. Having selected it she seems to have sometimes painted her pictures directly on to the card, probably working from earlier sketches. The borders certainly greatly enhance her delicate and precise delineation of figures, and they play an integral part in the visual effect of the watercolours.

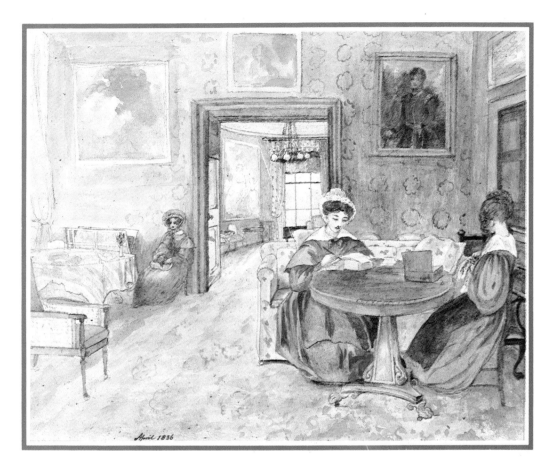

*Amelia Jane painted this charming watercolour of herself in
1836 long after she painted the fairies.*

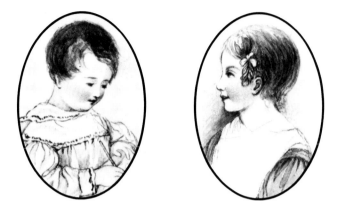

In 1829 Emily married, rather late in life by the standards of the time. Her husband, Sir John Oswald of Dunniker, was 29 years her senior, and had six children from his first wife. She left the Isle of Man, and went to live in Dunniker in Fife in Scotland, where she was herself to have two children. Her marriage marks the end of her work as an illustrator of fairyland. Her few surviving later drawings are concerned with capturing the likenesses of her children and stepchildren, and although she was to live until the great age of 96 she produced no more paintings.

Amelia Jane Murray's *Faery Bower* has been passed on through four generations of Murray family, and now reaches a wider public through the pages of this book. The work of her twenties survives today as much more than a mere historical curiosity – a nostalgic peep into the forgotten world of the ladies 'Keepsake' albums of the Regency. Her watercolours occupy an important place in the peculiarly British phenomenon of fairy painting. Although an amateur her work can fairly be compared

with such great depictors of fairyland as George Cruik-
shank, Richard Dadd, Daniel Maclise, Noel Paton and
Richard Doyle. Her artistically valid fairy world reminds
us of John Ruskin's essay on *Fairyland* published in 1894,
two years before her death, in which he said 'A man can't
always do what he likes, but he can always fancy what he
likes.' Emily's fancies still captivate us, over 150 years later.

LIONEL LAMBOURNE
Assistant Keeper of Paintings
Victoria and Albert Museum

PROSPERO:

 Ye elves of hills, brooks, standing lakes and
groves,
And ye that on the sands with printless foot
Do chase the ebbing Neptune and do fly him
When he comes back; you demi-puppets that
By moonshine do the green sour ringlets make,
Whereof the ewe not bites, and you whose pastime
Is to make midnight mushrooms, that rejoice
To hear the solemn curfew; by whose aid,
Weak masters though ye be, I have bedimm'd
The noontide sun, call'd forth the mutinous winds,
And 'twixt the green sea and the azured vault
Set roaring war: to the dread rattling thunder
Have I given fire and rifted Jove's stout oak
With his own bolt; the strong-based promontory
Have I made shake and by the spurs pluck'd up
The pine and cedar: graves at my command
Have waked their sleepers, oped, and let 'em forth
By my so potent art.

<div align="right">

WILLIAM SHAKESPEARE
From *The Tempest Act V*

</div>

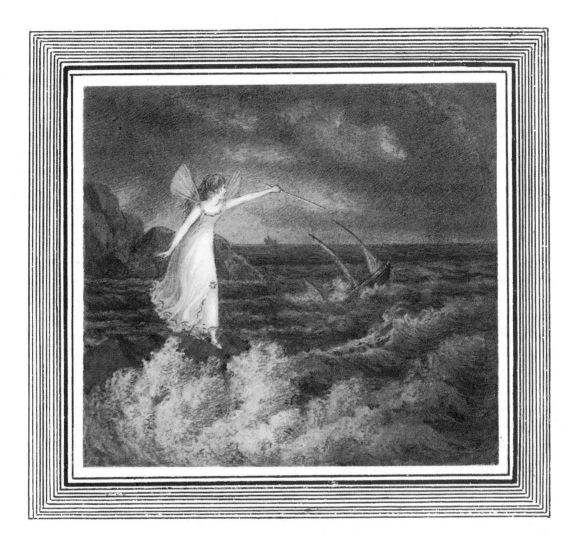

And there six crickets draw her fast,
When she a journey takes in haste;
Or else two serve to pace a round,
And trample on the fairy-ground.
In hawks sometimes she takes delight,
Which hornets are most swift in flight;
Whose horns instead of talons will
A fly, as hawks a partridge, kill.
But if she will a hunting go,
Then she the lizzard makes the doe,
Which is so swift and fleet in chase,
As her slow coach cannot keep pace;
Then on a grasshopper she'll ride,
And gallop in the forest wide;
Her bow is of a willow branch,
To shoot the lizzard on the haunch;
Her arrow sharp, much like a blade,
Of a rosemary leaf is made.

MARGARET CAVENDISH Duchess of Newcastle
From *The Pastime and Recreation of
 the Queen of the Fairies in Fairy-Land
 The Centre of the Earth*

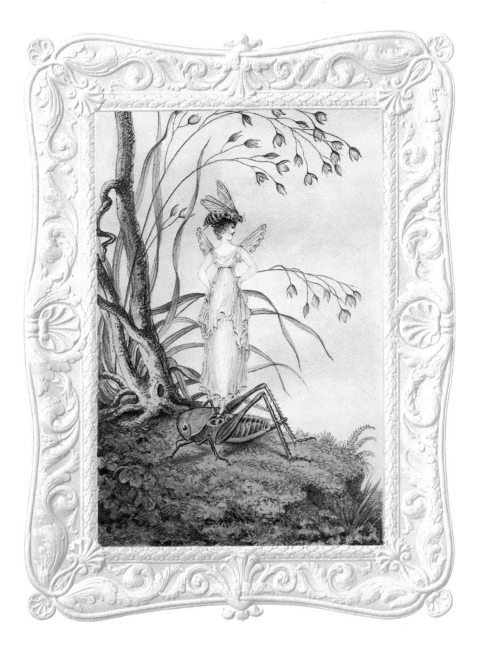

O'er the smooth enameled green
Where no print of step hath been,
 Follow me as I sing,
 And touch the warbled string.
Under the shady roof
Of branching elm star-proof,
 Follow me;
I will bring you where she sits,
Clad in splendor as befits
 Her deity.
Such a rural Queen
All Arcadia hath not seen.

JOHN MILTON
From *Arcades*

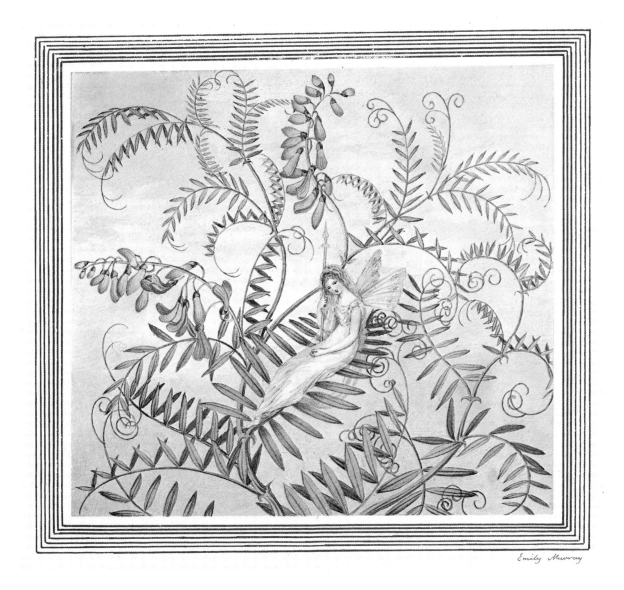

Emily Mcaway

[23]

OBERON:

 I know a bank whereon the wild thyme blows,
Where Oxlips and the nodding Violet grows
Quite over-canopied with luscious woodbine,
With sweet musk-roses, and with Eglantine:
There sleeps *Titania* sometime of the night,
Lull'd in these flowers with dances and delight;
And there the snake throws her enamell'd skin,
Weed wide enough to wrap a Fairy in.

WILLIAM SHAKESPEARE
From *A Midsummer Night's Dream Act II*

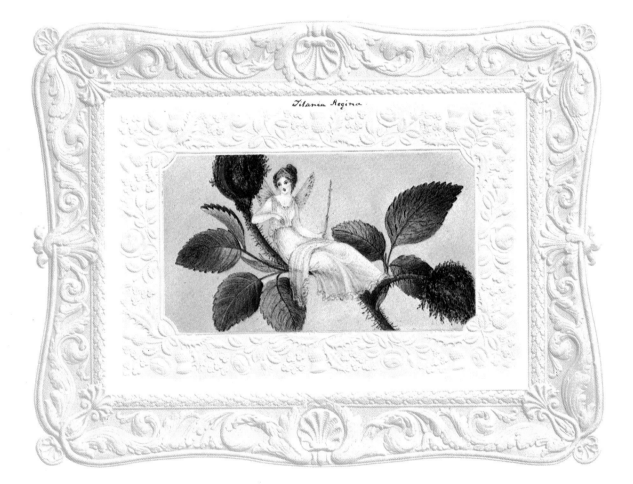

Titania Regina

ARIEL:

 Where the bee sucks, there suck I:
In a cowslip's bell I lie;
There I couch when owls do cry.
On the bat's back I do fly
After summer merrily;
Merrily, merrily, shall I live now,
Under the blossom that hangs on the bough.

WILLIAM SHAKESPEARE
From *The Tempest Act V*

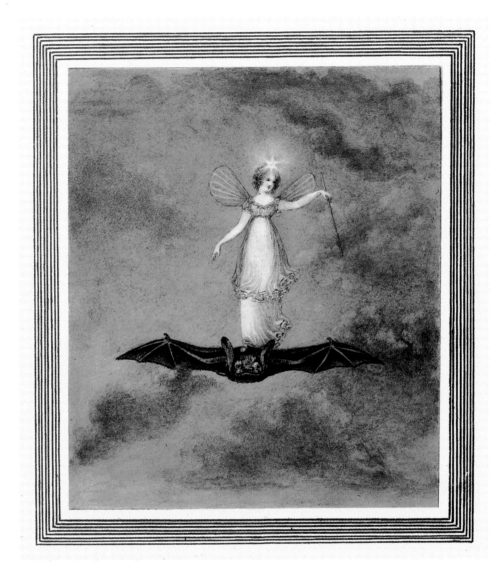

From the forests and highlands
　　We come, we come;
From the river-girt islands,
　　Where loud waves are dumb,
Listening to my sweet pipings.
　　The wind in the reeds and the rushes,
　　　The bees on the bells of thyme,
　　The birds on the myrtle bushes,
　　　The cicale above in the lime,
And the lizards below in the grass,
Were as silent as ever old Tmolus was,
Listening to my sweet pipings.

PERCY BYSSHE SHELLEY
From the *Hymn of Pan*

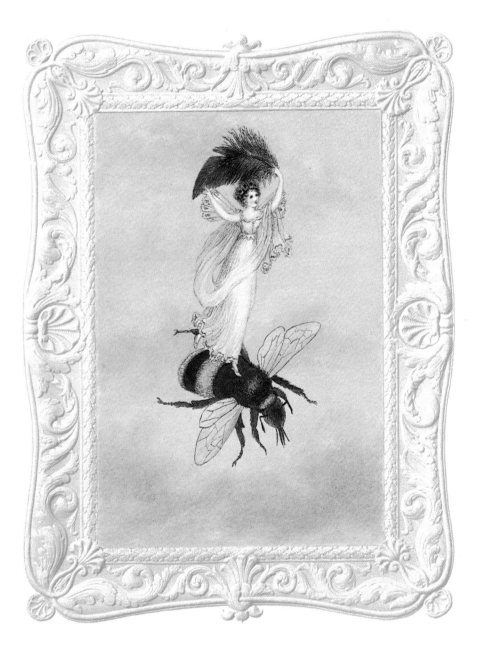

I'll give thee fairies to attend on thee;
And they shall fetch thee jewels from the deep,
And sing, while thou on pressed flowers
 dost sleep;
And I will purge thy mortal grossness so
That thou shalt like an airy spirit go.

WILLIAM SHAKESPEARE
From *A Midsummer Night's Dream Act III*

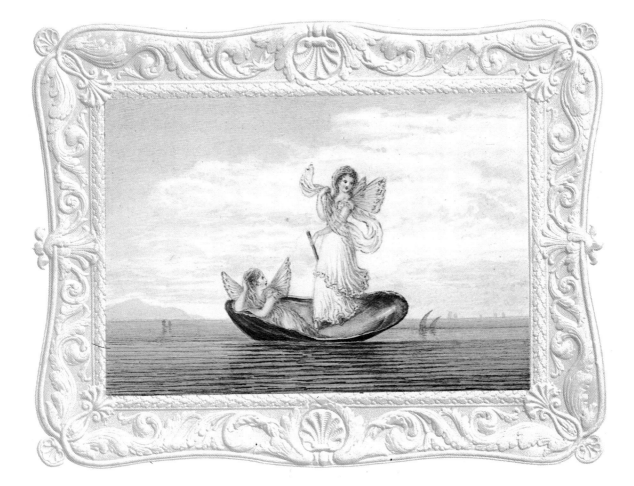

I am drunk with the honey wine
Of the moon-unfolded eglantine,
Which fairies catch in hyacinth bowls.
The bats, the dormice, and the moles
Sleep in the walls or under the sward
Of the desolate castle yard;
And when 'tis spilt on the summer earth
　Or its fumes arise among the dew,
Their jocund dreams are full of mirth,
　They gibber their joy in sleep; for few
　Of the fairies bear those bowls so new!

PERCY BYSSHE SHELLEY
Wine of the Fairies

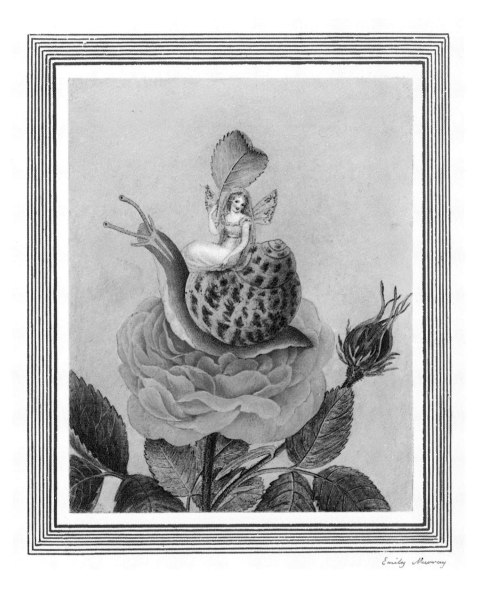

Emily Murray

On tops of dewy grass
So nimbly do we pass,
The young and tender stalk
Ne'er bend when we do walk:
Yet in the morning may be seen
Where we the night before have been.

ANONYMOUS

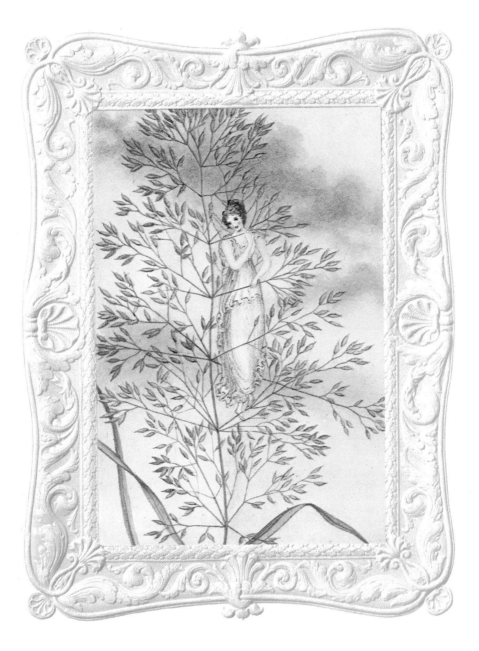

Let us play, and dance and
 sing!
Let us frolick let us sport,
Turning the delights of Spring
 To the graces of a court.
From Air, from cloud from
 dreams and toys,
To sounds, to sense, to love and
 joys!

Well were the solemn rites
 begun;
And tho' but lighted by
 the moon,
They shew'd as rich as if the
 Sun
 Had made the Night his Noon.
Wonder none they were so bright!
The Moon then borrow'd from a
 greater light.
 Then, Princely Oberon,
 Go, on!
 Sad is not every Night.

Tho' the Moon be gone to bed,
Fairies must not hide the
 Head.
But sing, dance, and revel
 on,
In honour of Young Oberon.

 MICHAEL DRAYTON
 From *Nimphidia, the Court of Fayrie*
 [36]

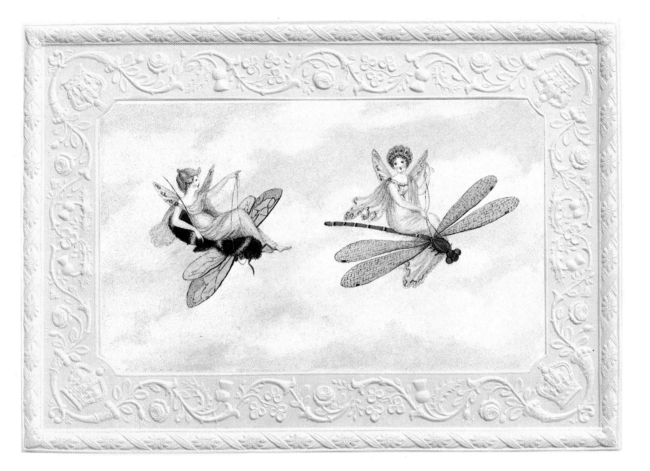

The faery beam upon you,
The stars to glister on you;
 A moon of light
 In the noon of night,
Till the fire-drake hath o'ergone you!
The wheel of fortune guide you,
The boy with the bow beside you;
 Run aye in the way
 Till the bird of day,
And the luckier lot betide you!

BEN JONSON
Gipsy Song

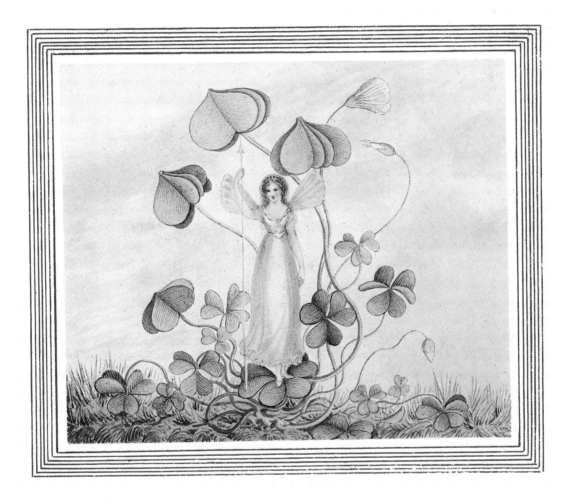

A little fairy comes at night,
Her eyes are blue, her hair is brown,
With silver spots upon her wings,
And from the moon she flutters down.

THOMAS HOOD
From *Queen Mab*

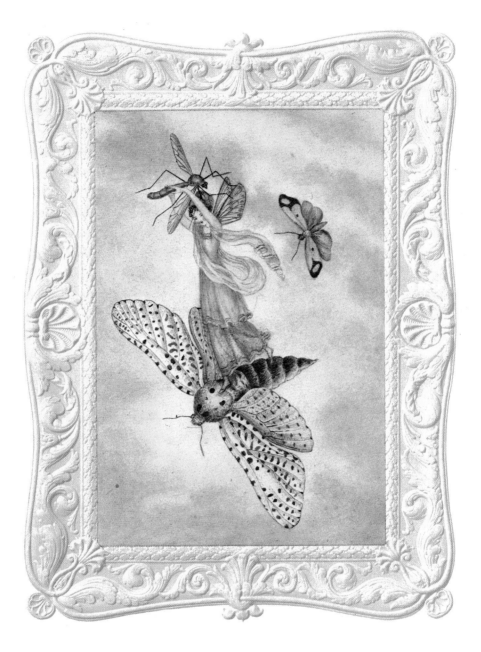

PUCK:

 How now, spirit! whither wander you?

FAIRY:

 Over hill, over dale,
Thorough bush, thorough brier,
Over park, over pale,
Thorough flood, thorough fire,
I do wander everywhere,
Swifter than the moon's sphere;
And I serve the fairy queen,
To dew her orbs upon the green.
The cowslips tall her pensioners be:
In their gold coats spots you see;
Those be rubies, fairy favours,
In those freckles live their savours:
I must go seek some dewdrops here
And hang a pearl in every cowslip's ear.

WILLIAM SHAKESPEARE
From *A Midsummer Night's Dream Act II*

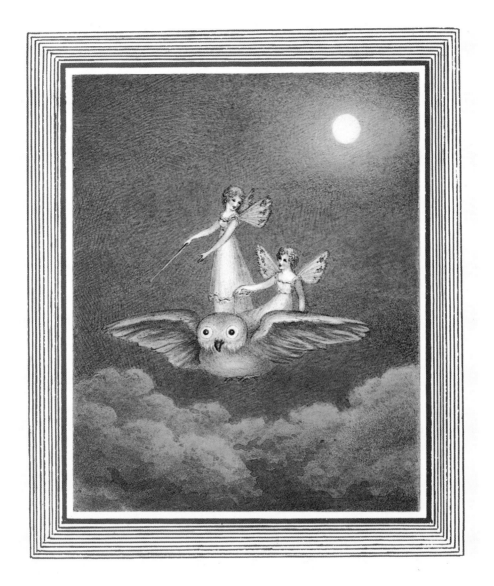

All hand in hand, around, around,
They dance upon this fairy-ground;
And when she leaves her dancing ball,
She doth for her attendants call,
To wait upon her to a bower,
Where she doth sit under a flower,
To shade her from the moon-shine bright,
Where gnats do sing for her delight.
Some high, some low, some middle strain,
Making a concert very plain;
The whilst the bat doth fly about,
To keep in order all the rout,
And with her wings doth soundly pay
Those, that make noise, and not obey.
A dewy waving leaf's made fit
For the Queen's bath, where she doth sit,
And her white limbs in beauty show,
Like a new fallen flake of snow;
Her maids do put her garments on,
Made of the pure light from the sun,
Which do so many colours take,
As various objects shadows make:

MARGARET CAVENDISH Duchess of Newcastle
From *The Pastime and Recreation of*
the Queen of Fairies in Fairy-Land
The Centre of the Earth

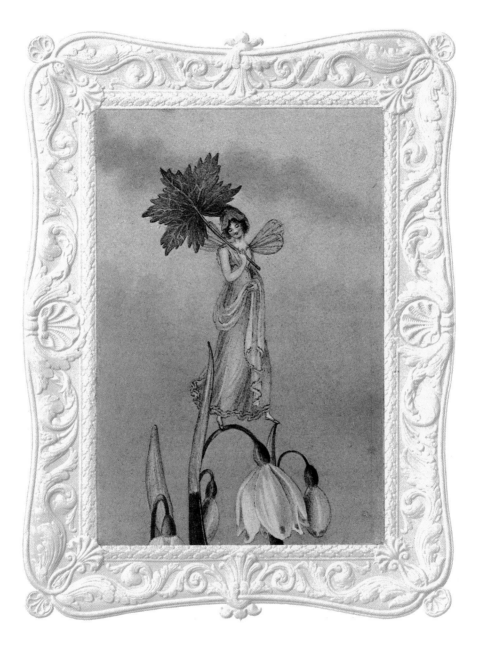

Sabrina fair,
 Listen where thou art sitting
Under the glassy, cool, translucent wave,
 In twisted braids of lilies knitting
The loose train of thy amber-dropping hair;
 Listen for dear honor's sake,
 Goddess of the silver lake,
 Listen and save.

JOHN MILTON
From *Comus*

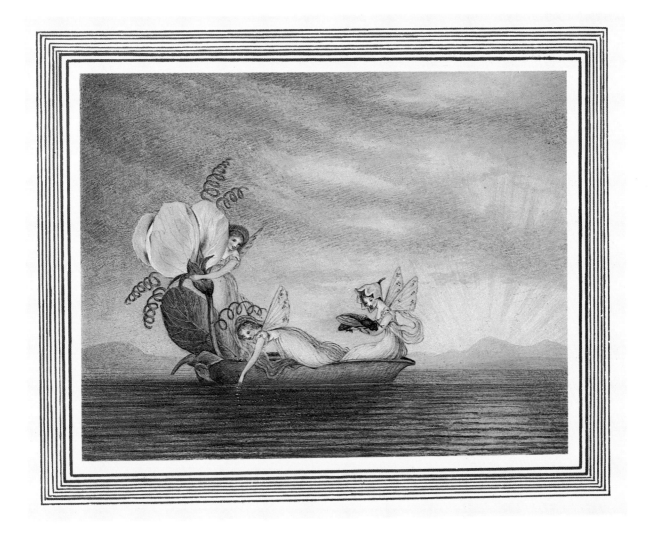

TITANIA:

 Come now, a roundel and a fairy song;
Then for the third part of a minute, hence:
Some to kill cankers in the musk-rose buds
Some war with rere-mice for their leathern wings,
To make my small elves coats, and some keep back
The clamorous owl that nightly hoots and wonders
At our quaint spirits. Sing me now asleep;
Then to your offices and let me rest.

WILLIAM SHAKESPEARE
From *A Midsummer Night's Dream Act II*

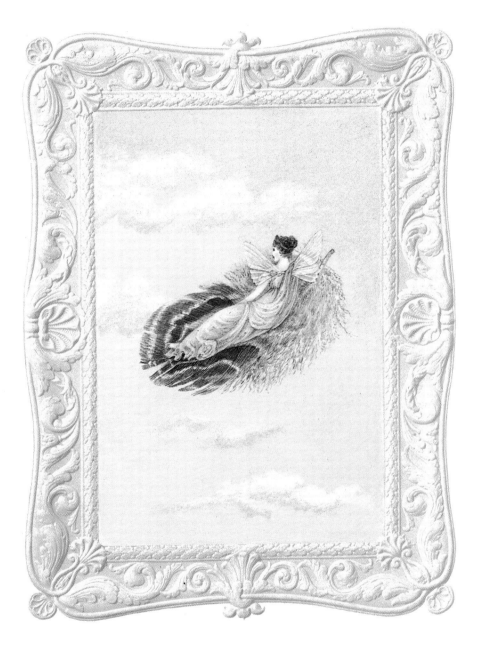

Queen, and huntress, chaste, and fair,
Now the sun is laid to sleep,
Seated, in thy silver chair,
State in wonted manner keep:
 Hesperus, entreats thy light,
 Goddess, excellently bright.

Earth, let not thy envious shade
Dare itself to interpose;
Cynthia's shining orb was made
Heaven to clear, when day did close:
 Bless us then with wishèd sight,
 Goddess excellently bright.

Lay thy bow of pearl apart,
And thy crystal shining quiver;
Give unto the flying hart
Space to breathe, how short soever:
 Thou that mak'st a day of night,
 Goddess excellently bright.

BEN JONSON
From *Cynthia's Revels*

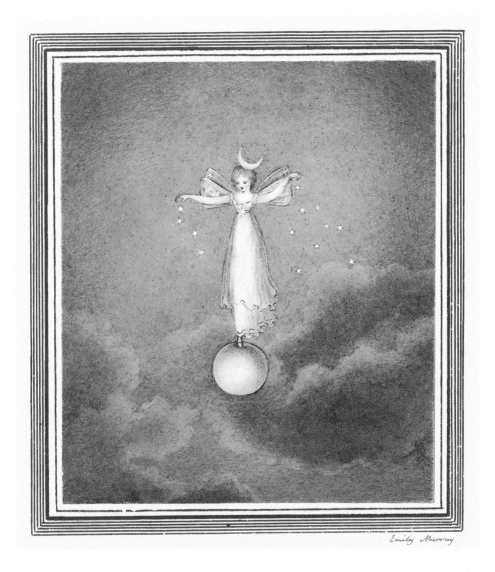

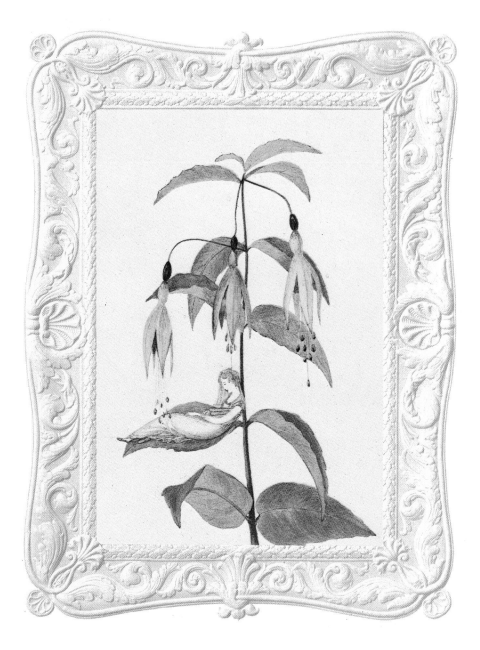

AMELIA JANE MURRAY'S

Family Background

SIR IAIN MONCREIFFE OF THAT ILK, BT.

Love for the enchanted Isle of Man was instilled into me from the age of fifteen by my then closest grown-up male relation Lord James Murray, later ninth Duke of Atholl, who shared Easter Moncreiffe with me until his death, spoke Gaelic before he learnt English and was the heir of the old Manx royal family. Through him, I got to know Fay Manannan's Isle well: being armed on my first visit with introductions from the duke to the amiable Governor, worthy Bishop, wise Senior Deemster and, above all, to Basil Megaw who in those days was curator of the Manx Museum and a living repository of the island's story.

As you move about this tiny once-upon-a-time kingdom, the scenery changes every few minutes: at one moment you're in the fens, then on high moorland, next past houses set amidst sub-tropical vegetation, and suddenly in a tree-lined watery glen or dell. And if you come from the southside of the island, never fail

to doff your hat to the fairies as you cross Ballalona Bridge which divides the North from the South.

Amelia Jane Murray, known to her family and friends as Emily, the painter of these delightful watercolours of fairies, was herself very much a member of the former Manx dynastic house, who had issued their own coins and held their own parliament, the House of Keys. Her father Harry, Lord Henry Murray, had been appointed the Lt-Colonel of the Royal Manx Fencibles by his brother, the fourth Duke of Atholl, Governor of the Island. Their father, the third Duke, having been the last Sovereign Lord of the Isle of Man. Emily's mother, Lady Henry Murray, had been born Elizabeth Kent, of a family from Lancashire on the mainland opposite Mann, and were descendants of the very old family of the Lancelyns of Poolton Lancelyn who had been there since the eleventh century.

The Murrays themselves are one of the greatest of the historic houses who went to the making of Scotland. Their first forefather to settle there had come by the invitation of King David I (1124-1156) when Scotland was being forged out of a melting pot of many races. He was a Frisian noble called Freskin, son of Ollec. Freskin's sons were the greatest lords in the province of Moray, from which they therefore took their surname of Moray or Murray. Indeed, there are reasons why it is thought likely that Freskin had married a lady of the former Picto-Scottish royal house of Moray.

In 1235 one of Freskin's family, Sir William of Murray, was created the first Earl of Sutherland, at a time when earldoms were only granted to relations of the king or of former local royal

houses; and about the same time another, the late Bishop of Caithness, was canonised as Saint Gilbert of Murray. The chiefs of the Name became the powerful Barons of Bothwell and in 1297 their heir, young Sir Andrew of Murray, was the principal of the two 'leaders of the army of the kingdom of Scotland' who rose up against Edward I's occupation of Scotland and smote the English at the battle of Stirling Bridge where, alas for the Scots, Sir Andrew was mortally wounded. It is thought that this victory was due to Murray's generalship and, after his death, his junior colleague Sir William Wallace, although a brilliant guerilla, never won a pitched battle again. This national hero's son, also Sir Andrew of Murray, lord of Bothwell, ended a remarkable warrior career as Regent of Scotland (1332-1338), having married a sister of King Robert the Bruce. But their son, the last lord of Bothwell perished of the plague during the Black Death.

Meanwhile, yet another scion of Freskin's family, Emily Murray's then forefather, had settled in Perthshire, where his descendants remain to this day as Dukes of Atholl at Blair Castle and Earls of Mansfield at Scone Palace. This scion was Sir Malcolm of Murray, Sheriff of Perth, who died before 1289, having married the heiress of Gask in Strathearn. Sir Malcolm's son married the heiress of Tullibardine, also in Strathearn; but their son Andrew was executed in 1332 for treason in adhering to the lost Balliol cause. Nevertheless, Tullibardine was erected into a feudal Barony by King James II in 1444, giving the Murrays' baronial Court powers of life and death.

In the sixteenth century the Laird of Tullibardine was one of the Lords of the Congregation who brought about the Reformation in Scotland; and his son, stout-hearted Sir William Murray of Tullibardine was given joint custody to bring up the son of Mary Queen of Scots, the boy-king James VI. Murray chieftains from all over Scotland, with their kinsman the Laird of Moncreiffe,

signed a 'band of association' in lawless 1586 under Tullibardine's leadership for the mutual 'defence of our rooms, tacks, steadings, goods and gear, which by the incursions of broken men, and unthankful unnatural neighbours, may appear to be in danger.' In 1600 the Murrays rallied to the King's side in the mysterious Gowrie House Affair, and were richly rewarded from Gowrie's forfeited estates. Four years later, King James VI made his foster-brother Sir John Murray a peer, and in 1606 created him Earl of Tullibardine. The second Earl, hereditary Sheriff of Perthshire, married Lady Dorothy Stewart, heiress of the fifth Earl of Atholl (whose family had held that great highland province, once a Pictish kingdom, since King James II granted it to his half-brother Sir John Stewart in 1457); and in 1629 their son John was recognised as Earl of Atholl.

Atholl and Argyll, both little kingdoms in the Dark Ages, still had their rival external policies as earldoms. John Murray, Earl of Atholl was a Royalist under Charles I and was treacherously taken prisoner by the Covenanting leader, the Earl of Argyll, chief of Clan Campbell, in violation of Argyll's promise of safe-conduct. He was so maltreated that he died not long after his release. So the Athollmen did as much damage as they could to the Argyll Campbells throughout the civil wars of the seventeenth century.

From the Whig Revolution, the Atholl family was genuinely divided in political allegiance for five reigns. John Murray, first Duke of Atholl from 1703, was a sincere Whig but bitterly opposed to the Union with England, against which he mobilised four thousand armed Athollmen in an unavailing demonstration of strength. His eldest son Tullibardine was killed in action under Marlborough at Malplaquet. The exiled next son, 'Duke William,' was created Jacobite Duke of Rannoch, raised Bonnie Prince Charlie's standard at Glenfinnam and died a prisoner in the Tower of London, awaiting trial and execution. The third son 'Duke

James', was a sincere Whig like his father and succeeded as second Duke of Atholl by a special act of parliament. The fifth son, Lord George Murray, was one of the greatest highlanders that will ever have lived. As his own son became third duke and married Duke James' daughter, the brothers Lord George and Duke James were both grandfathers of Emily's father Lord Henry Murray.

Lord George Murray, a Gaelic-speaking guerrilla leader who habitually wore the kilt 'on the hill' and marched on foot at the head of his men, was the brilliant Jacobite general who commanded Prince Charles Edward's army in the 1745 Rising. He proudly bore his maternal 'Douglas heart' on his bookplate as his personal heraldic 'difference' at the centre of the Atholl quarterings, and his crest was the old Murray peacock's head. His brother Duke James had secured him a pardon for his past in two earlier Risings, and all he wanted was a quiet life at Tullibardine. So, when summoned to the Jacobite standard in 1745, Lord George loyally donned the White Cockade again, but wrote sadly to the duke: 'My Life, my Fortune, my expectations, the Happyness of my wife and children, are all at stake (and the chances are against me), and yet a principle of (what seems to me) Honour, and my Duty to King and Country, outweighs evry thing . . . I will not venture to recommend her and my children to your protection. All I shall say on that head is, that a man of worth never repented of doing good natur'd offices.' In exile long after the final disaster at Culloden, fought against Lord George's advice, the Chevalier Johnstone, who had been the prince's A.D.C., wrote: 'had Prince Charles slept during the whole of the expedition, and allowed Lord George Murray to act for him according to his own judgment, he would have found the crown of Great Britain on his head when he awoke.' Such was Lord Henry Murray's grandfather, who died in exile in Holland.

But although Lord Henry's other grandfather, Duke James,

never replied to Lord George's sad letter quoted above, he did provide for Lord George's son, who succeeded as third Duke of Atholl and whose marriage Duke James arranged to his own daughter and heiress Lady Charlotte Murray, Baroness Strange and Sovereign Lady of the Isle of Man. For it was Duke James who had first brought the Murray family to Mann in 1736, when he succeeded his cousin Lord Derby as Sovereign Lord of the Island. His Manx coins with an A ensigned with a duke's coronet super-seded the Stanley coins with their Lathom eagle-and-child crest, the 'bird and bantling', but all have the three legs of Mann on the obverse. The Manx inheritance had come to him through the marriage of his grandparents: John Murray, Marquis of Atholl and Lady Amelia Stanley.

Lady Amelia's family had ruled the island since it was granted with its crown by Henry IV of England in 1406 to Sir John Stanley, K.G., whose family were of Anglo-Saxon origin and who thus became 'by the Grace of God King of Mann and the Isles.' The third King, also a Knight of the Garter, became Lord Stanley on the mainland in 1456 and was Lord Chamberlain to Henry VI at the outbreak of the Wars of the Roses. The fourth King of Mann played a decisive role in 1485 at the battle of Bosworth, where he set the slain Richard III's crown (found in the thorn-bush) on the head of the victorious Henry VII, who promptly created him Earl of Derby. (His son became by marriage Lord Strange, a title which was recreated in error later and passed through the Derbys and Atholls to the late John Drummond, fifteenth Lord Strange, whose daughter April now owns Emily Murray's fairy paintings.)

The fifth King of Mann was Thomas, 2nd Earl of Derby (1504-1521) who, noting Tudor policy towards the remaining Irish local kings, wisely declared that he would rather be a great lord than a petty king, and assumed instead the style of Sovereign Lord of the Isle of Man. After the Reformation, in 1541, the next Lord of Mann was proclaimed Head of the Manx Church (and thereafter the Derby and Atholl families continued to appoint their own Bishops down to 1784, when the then heiress, the Dowager Duchess of Atholl made the last dynastic appointment despite the London Government's having compulsorily purchased the Sovereign Lordship for the British Crown: leaving only unspecified manorial rights to the Atholl family). James, 7th Earl of Derby, K.G., Sovereign Lord (1642-1651) had such an effect on the island's story that he is remembered as the Great Stanley: the *Stanlagh Mooar*. When summoned by Ireton to surrender the island to the Roundheads, he replied:

> 'Refrain from further solicitations of this nature, else I will
> cause burn the paper and hang the bearer. I am he who counts
> it his chiefest honour to be
> His Majesty's most humble and obedient Servant
> James Derby.'

Later he was captured in battle on the mainland, yielding on a promise of quarter which the Roundheads promptly violated by having him beheaded.

His daughter Lady Amelia Stanley, Marchioness of Atholl brought some of the grandest genes in Europe to the Murrays. She is what is known to genealogists as a 'gateway ancestor,' since her own ancestry was of such exceptional interest that it has been widely researched by scholars and proof of descent from her is therefore much coveted. Indeed, her ancestry can be traced with reasonable probability through various women to a Caucasian

king, born in the lifetime of Alexander the Great, who died in 323 BC. Her father Derby was not only heir of the De Vere earls of Oxford, the very epitome of coronets and Norman blood, but also descended from the great Elizabethan statesman William Cecil, Lord Burghley, from King Henry VIII's sister Mary, Duchess of Suffolk, whose mother was the Plantagenet heiress, another 'gateway ancestor', and from most of the historic families that made mediaeval England.

The Marshioness of Atholl's mother, Charlotte de La Tremoille, was the Countess of Derby, known to readers of Sir Walter Scott's *Peveril of the Peak,* as the heroic defender of Lathom House for the Cavaliers. Her mother in turn was daughter of William the Silent, Prince of Orange, the founder of the Dutch Republic who was assassinated while freeing Holland from Spain – by his Bourbon wife, a runaway abbess who turned Protestant. Lady Derby's other grandmother was daughter of Anne duc de Montmorency, Constable of France, 'sans peur et sans reproche.' Other colourful forebears included King Charles VII of France (Joan of Arc's dauphin) and his mistress Agnes Sorel, the brave Byzantine imperial house of Lascaris who had settled down at Vintimille on the Riviera, and King Ferrante of Naples whose mother was probably a half-caste Moor and who fed his foes to his pet crocodile.

It's of particular interest in the context of this book that Emily Murray had four lines of descent from the House of Savoy who were heirs of the Lusignans, Kings of Cyprus and titular crusader Kings of Jerusalem. Here indeed we can hear the horns of elfland faintly blowing. For through the romantic House of Lusignan, Emily had 'a poignant ancestral spirit, *Melusine,* the tutelary fairy

of their line. She was the spirit of the fountain of Lusignan, a forest spring in Poitou. The tale runs that once upon a time a young lord was wandering in the woods when he came upon a fair maiden by the spring, and proposed to her. She accepted him on condition that he never saw her on a Saturday. They were married in style, and lived happily for a long time, while she bore him an heir and helped him to build the castle of Lusignan from which the family was to take its famous surname. But one Saturday her husband could restrain his curiosity no longer, and peeped at her secretly. To his astonishment, she had become a snake – symbol of water – from the hips downwards: rather like a serpentine mermaid. He rashly gave himself away by exclaiming "ha, serpent": whereupon Melusine gave a shriek and flew out through a window of the castle, never to be seen again. "Thenceforth the death of a member of the house of Lusignan was heralded by the cries of the fairy serpent. 'Poussez des cris de Melusine' is still a popular saying. No wonder Emily Murray's childhood home was called Port-e-Chee, which in Manx Gaelic means 'Fairy Music'.

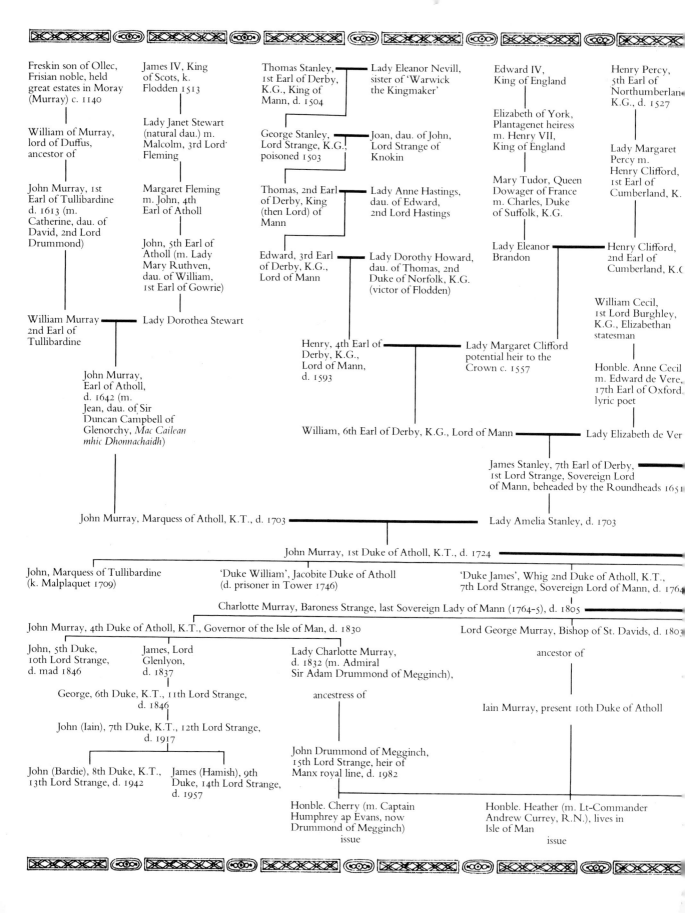

Freskin son of Ollec, Frisian noble, held great estates in Moray (Murray) c. 1140

William of Murray, lord of Duffus, ancestor of

John Murray, 1st Earl of Tullibardine d. 1613 (m. Catherine, dau. of David, 2nd Lord Drummond)

James IV, King of Scots, k. Flodden 1513

Lady Janet Stewart (natural dau.) m. Malcolm, 3rd Lord Fleming

Margaret Fleming m. John, 4th Earl of Atholl

John, 5th Earl of Atholl (m. Lady Mary Ruthven, dau. of William, 1st Earl of Gowrie)

William Murray 2nd Earl of Tullibardine ━━ Lady Dorothea Stewart

John Murray, Earl of Atholl, d. 1642 (m. Jean, dau. of Sir Duncan Campbell of Glenorchy, *Mac Cailean mhic Dhonnachaidh*)

Thomas Stanley, 1st Earl of Derby, K.G., King of Mann, d. 1504 ━━ Lady Eleanor Nevill, sister of 'Warwick the Kingmaker'

George Stanley, Lord Strange, K.G., poisoned 1503 ━━ Joan, dau. of John, Lord Strange of Knokin

Thomas, 2nd Earl of Derby, King (then Lord) of Mann ━━ Lady Anne Hastings, dau. of Edward, 2nd Lord Hastings

Edward, 3rd Earl of Derby, K.G., Lord of Mann ━━ Lady Dorothy Howard, dau. of Thomas, 2nd Duke of Norfolk, K.G. (victor of Flodden)

Henry, 4th Earl of Derby, K.G., Lord of Mann, d. 1593 ━━ Lady Margaret Clifford potential heir to the Crown c. 1557

Edward IV, King of England

Elizabeth of York, Plantagenet heiress m. Henry VII, King of England

Mary Tudor, Queen Dowager of France m. Charles, Duke of Suffolk, K.G.

Lady Eleanor Brandon ━━ Henry Clifford, 2nd Earl of Cumberland, K.G.

Henry Percy, 5th Earl of Northumberland, K.G., d. 1527

Lady Margaret Percy m. Henry Clifford, 1st Earl of Cumberland, K.

William Cecil, 1st Lord Burghley, K.G., Elizabethan statesman

Honble. Anne Cecil m. Edward de Vere, 17th Earl of Oxford, lyric poet

William, 6th Earl of Derby, K.G., Lord of Mann ━━ Lady Elizabeth de Vere

James Stanley, 7th Earl of Derby, 1st Lord Strange, Sovereign Lord of Mann, beheaded by the Roundheads 1651

John Murray, Marquess of Atholl, K.T., d. 1703 ━━ Lady Amelia Stanley, d. 1703

John Murray, 1st Duke of Atholl, K.T., d. 1724 ━━

John, Marquess of Tullibardine (k. Malplaquet 1709)

'Duke William', Jacobite Duke of Atholl (d. prisoner in Tower 1746)

'Duke James', Whig 2nd Duke of Atholl, K.T., 7th Lord Strange, Sovereign Lord of Mann, d. 1764

Charlotte Murray, Baroness Strange, last Sovereign Lady of Mann (1764–5), d. 1805 ━━

John Murray, 4th Duke of Atholl, K.T., Governor of the Isle of Man, d. 1830

Lord George Murray, Bishop of St. Davids, d. 1803

John, 5th Duke, 10th Lord Strange, d. mad 1846

James, Lord Glenlyon, d. 1837

Lady Charlotte Murray, d. 1832 (m. Admiral Sir Adam Drummond of Megginch), ancestress of

ancestor of

George, 6th Duke, K.T., 11th Lord Strange, d. 1846

Iain Murray, present 10th Duke of Atholl

John (Iain), 7th Duke, K.T., 12th Lord Strange, d. 1917

John (Bardie), 8th Duke, K.T., 13th Lord Strange, d. 1942

James (Hamish), 9th Duke, 14th Lord Strange, d. 1957

John Drummond of Megginch, 15th Lord Strange, heir of Manx royal line, d. 1982

Honble. Cherry (m. Captain Humphrey ap Evans, now Drummond of Megginch) issue

Honble. Heather (m. Lt-Commander Andrew Currey, R.N.), lives in Isle of Man issue

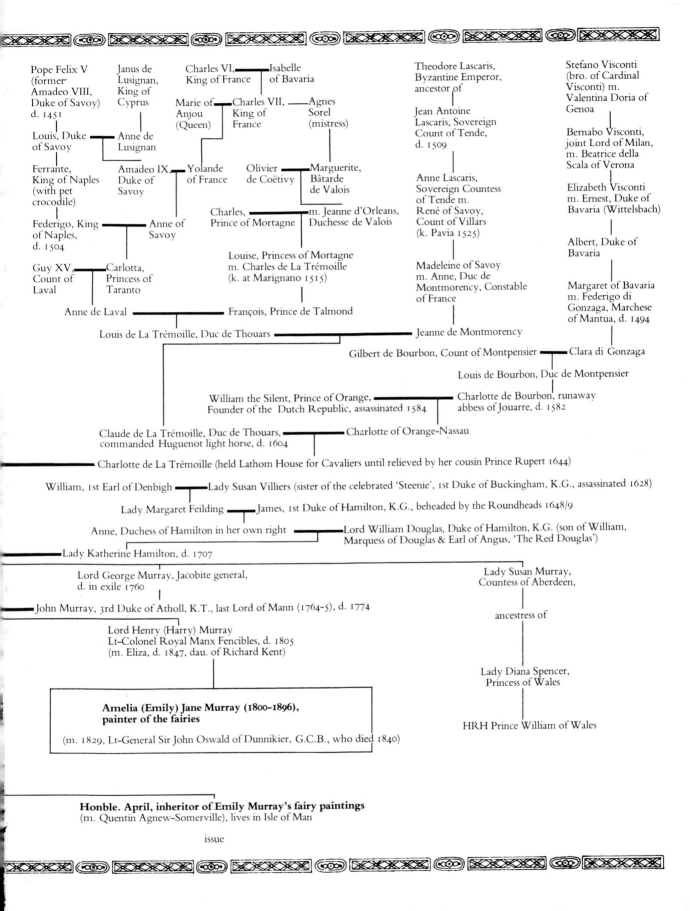

Pope Felix V (former Amadeo VIII, Duke of Savoy) d. 1451

Janus de Lusignan, King of Cyprus

Charles VI, King of France ——— Isabelle of Bavaria

Theodore Lascaris, Byzantine Emperor, ancestor of

Stefano Visconti (bro. of Cardinal Visconti) m. Valentina Doria of Genoa

Marie of Anjou (Queen) ——— Charles VII, King of France ——— Agnes Sorel (mistress)

Jean Antoine Lascaris, Sovereign Count of Tende, d. 1509

Bernabo Visconti, joint Lord of Milan, m. Beatrice della Scala of Verona

Louis, Duke of Savoy ——— Anne de Lusignan

Ferrante, King of Naples (with pet crocodile)

Amadeo IX, ——— Yolande Duke of Savoy of France

Olivier de Coëtivy ——— Marguerite, Bâtarde de Valois

Anne Lascaris, Sovereign Countess of Tende m. René of Savoy, Count of Villars (k. Pavia 1525)

Elizabeth Visconti m. Ernest, Duke of Bavaria (Wittelsbach)

Federigo, King of Naples, d. 1504 ——— Anne of Savoy

Charles, Prince of Mortagne ——— m. Jeanne d'Orleans, Duchesse de Valois

Albert, Duke of Bavaria

Louise, Princess of Mortagne m. Charles de La Trémoille (k. at Marignano 1515)

Madeleine of Savoy m. Anne, Duc de Montmorency, Constable of France

Margaret of Bavaria m. Federigo di Gonzaga, Marchese of Mantua, d. 1494

Guy XV, Count of Laval ——— Carlotta, Princess of Taranto

Anne de Laval ——————— François, Prince de Talmond

Louis de La Trémoille, Duc de Thouars ——————— Jeanne de Montmorency

Gilbert de Bourbon, Count of Montpensier ——— Clara di Gonzaga

Louis de Bourbon, Duc de Montpensier

William the Silent, Prince of Orange, Founder of the Dutch Republic, assassinated 1584 ——— Charlotte de Bourbon, runaway abbess of Jouarre, d. 1582

Claude de La Trémoille, Duc de Thouars, commanded Huguenot light horse, d. 1604 ——— Charlotte of Orange-Nassau

Charlotte de La Trémoille (held Lathom House for Cavaliers until relieved by her cousin Prince Rupert 1644)

William, 1st Earl of Denbigh ——— Lady Susan Villiers (sister of the celebrated 'Steenie', 1st Duke of Buckingham, K.G., assassinated 1628)

Lady Margaret Feilding ——— James, 1st Duke of Hamilton, K.G., beheaded by the Roundheads 1648/9

Anne, Duchess of Hamilton in her own right ——— Lord William Douglas, Duke of Hamilton, K.G. (son of William, Marquess of Douglas & Earl of Angus, 'The Red Douglas')

Lady Katherine Hamilton, d. 1707

Lord George Murray, Jacobite general, d. in exile 1760

Lady Susan Murray, Countess of Aberdeen,

John Murray, 3rd Duke of Atholl, K.T., last Lord of Mann (1764-5), d. 1774

ancestress of

Lord Henry (Harry) Murray Lt-Colonel Royal Manx Fencibles, d. 1805 (m. Eliza, d. 1847, dau. of Richard Kent)

Lady Diana Spencer, Princess of Wales

Amelia (Emily) Jane Murray (1800-1896), painter of the fairies

(m. 1829, Lt-General Sir John Oswald of Dunnikier, G.C.B., who died 1840)

HRH Prince William of Wales

Honble. April, inheritor of Emily Murray's fairy paintings
(m. Quentin Agnew-Somerville), lives in Isle of Man

issue

You spotted snakes with double tongue,
 Thorny hedgehogs, be not seen;
Newts, and blind-worms, do no wrong;
 Come not near our fairy queen.

 Philomel with melody
 Sing in our sweet lullaby;
Lulla, lulla, lullaby; lulla, lulla, lullaby!
Never harm, nor spell, nor charm,
 Come our lovely lady nigh!
 So good-night, with lullaby.

Weaving spiders, come not here;
 Hence, you long-legg'd spinners, hence;
Beetles black, approach not near;
 Worm, nor snail, do no offence.

 Philomel with melody
 Sing in our sweet lullaby;
Lulla, lulla, lullaby; lulla, lulla, lullaby!
Never harm, nor spell, nor charm,
 Come our lovely lady nigh!
 So good-night, with lullaby.

WILLIAM SHAKESPEARE
From *A Midsummer Night's Dream Act II*

[64]